CW00542880

Written and Directed by **Tim Fountain**

First performed at Soho Theatre on 9 June 2010

Soho Theatre is supported by
Arts Council England, Bloomberg, TEQUILA/London, Westminster City Council,
John Ellerman Foundation and Harold Hyam Wingate Foundation.

Performances in the Lorenz Auditorium

Registered charity number 267234

DANDY IN THE UNDERWORD

Written and Directed by **Tim Fountain**
Designed by **Paul Wills**
Lighting Design by **Philip Gladwell**
Sound Design by **Fergus O'Hare**

Assistant Director	Jason Moore
Casting Director	Nadine Rennie CDG
Company Stage Manager	Olivia Kerslake
Production Manager	Edward Wilson www.edwilsonproductions.co.uk
Set Building and Painting	Visual Scene Ltd
Costume Supervisor	Jackie Orton
Costume Maker	Adrian Gwillym at Academy Costumes
Technical Manager	Nick Blount
Press and PR	David Burns at Clout Communications Ltd www.cloutcom.co.uk
Publicity Photography	Muir Vidler www.muirvidler.com
Produced for Soho Theatre	by Louise Chantal www.chantalarts.co.uk

With thanks to: Sebastian Horsley; Nina Steiger; David Johnson; Stephen Fry; Nadine Rennie; Adrian Gwillym and Academy Costumes; Toby Young and Lisa Hilton; James Hogan and all at Oberon Books; Quintessentially Soho at The House of St Barnabas.

QUINTESSENTIALLY SOHO
AT THE HOUSE OF ST BARNABAS

Makeup provided by M.A.C

M·A·C

Cast

MILO TWOMEY, SEBASTIAN HORSLEY

Theatre credits: *Brief Encounter* (Kneehigh, UK and USA Tour); *Blithe Spirit, The Children's Hour, An Ideal Husband, She Stoops To Conquer, Harvey* (Royal Exchange Theatre); *Not The End Of The World* (Bristol Old Vic); *The Canterbury Tales* (Royal Shakespeare Company, Guilgud Theatre, West End); *The Tempest* (Southwark Playhouse); *Happy Yet?, La Musica Deuxieme, Danton's Death, Shakuntala* (The Gate Theatre); *The Bolero* (The Arcola); *Three Sisters* (number one tour); *A Busy Day* (Lyric Theatre, West End); *Glastonbury* (number one tour); *A Place At The Table* (national tour); *Macbeth* (Queens Theatre, West End).

Television credits: *My Spy Family* (two series), *Holby City, The Golden Hour, Trial & Retribution, Battle of Britain, Murder City, Dirty War, Odysseus, Bad Girls, Eastenders, Family Business, P.O.W., The Bill, Casualty, Doctors, Liverpool One, Band of Brothers, The Marchioness, London's Burning, Silent Witness* (one series).

Film includes: *Franklyn, Thespian X, The Jolly Boys Last Stand*.

Also, numerous radio plays for BBC Radio4.

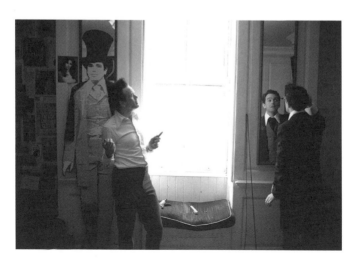

COMPANY

TIM FOUNTAIN, WRITER AND DIRECTOR

Tim Fountain's plays include *Sex Addict* (Royal Court); *Resident Alien* (Bush/National tour/New York Theatre Workshop, BBC Radio 3); *Julie Burchill is Away, Hotboi, How to Lose Friends and Alienate People* (Soho, Arts Theatre, West End); *Rock* (Oval House); *Midnight Cowboy* (Assembly Rooms, Edinburgh); *Cinderella* (Churchill Theatre, Bromley); *Once In a Blue Moon (Coventry Belgrade); Tchaikovsky in the Park* (Bridewell) and *Harold's Day (BAC).* His directing credits include *Resident Alien* (UK, US and Australian Tours and New End); *Puppetry of the Penis* (Whitehall/Apollo Theatre, West End, numerous national tours); *Anorak of Fire* (Pleasance, *Edinburgh) Grandmotherfucker* (Assembly Rooms, Edinburgh); *Last Bus From Bradford (Chelsea Theatre).* Tim was a principal writer on the animated sitcom *Bob and Margaret* (Comedy Central/Channel Four). His books include *Rude Britannia* (Weidenfeld and Nicolson); *Quentin Crisp* (Absolute Press) and *So You Want to be a Playwright?* (Nick Hern). Tim also presented the Channel Four Documentary *The Significant Death of Quentin Crisp.* He was Literary Manager of the Bush theatre from 1997-2001. www.timfountain.co.uk

PAUL WILLS, DESIGNER

Previous designs for Soho include *Overspill.*

Other theatre includes: *Novecento* (Donmar at Trafalgar Studios); *1984, Punk Rock* (also Lyric Hammersmith), *Macbeth* and *See How They Run* (Royal Exchange); *I Ought To Be In Pictures* (Manchester Library); *Sisters* (Sheffield); *Treasure Island* (Kingston); *Pornography* (Tricycle/Birmingham /Traverse); *Serious Money* (Birmingham); *The Man Who Had All the Luck, The Cut* (Donmar/Tour); *Home* (Bath); *Porridge* (Tour); *The Frontline, We The People* (Globe); *The Indian Wants The Bronx, Crave, Such A Beautiful Voice Is Sayeda's* and *The Suit* (Young Vic); *Testing The Echo* (Tricycle/Out of Joint); *This Much is True, Crestfall* (503); *Total Eclipse* (Menier); *Breathing Corpses* (Royal Court); *Metamorphosis* (Bromley); *Prometheus Bound* (Classic Stage, New York/The Sound Venue); *Mammals* (Bush/Tour); *Pinter triple bill* (Gate); *A Number* (Sheffield/Chichester); *Gladiator Games* (Sheffield /Stratford East); *Blue/Orange, Batina and the Moon* (Sheffield); *The Field* (Tricycle); *The Changeling, Mother Courage* (set, ETT); *Tracy Beaker Gets*

Real (Nottingham/Tour); *Invisible Mountains* (NT Education); *A Streetcar Named Desire* (Clwyd); *Oliver!* (Hereford); *A Thousand Yards* (Southwark); *References to Salvador Dali Make Me Hot, Gompers* (Arcola); *Car Thieves* (The Door, Birmingham); *Sleeping Beauty* (Helix, Dublin); *Little Voice* (Watermill) and *The School of Night* (The Other Place, RSC). Opera includes: *Rusalka* (ETO), *Sweetness and Badness* (WNO) and *The Magic Flute* (National Theatre of Palestine).

PHILIP GLADWELL
LIGHTING DESIGNER

Previously for Soho Theatre: *Shradda, Overspill, HOTBOI* and *Tape*

Theatre includes: *Love The Sinner* (National Theatre); *Low Pay? Don't Pay!* and *Drowning on Dry Land* (Salisbury Playhouse); *Nineteen Eighty-Four* and *Macbeth* (Royal Exchange Manchester); *Punk Rock* (Lyric Hammersmith/ Royal Exchange); *Testing The Echo* (Out Of Joint); *2nd May 1997* (Bush/ Tour); *Terminus* (Abbey, New York, Australia); *Oxford Street and Kebab* (Royal Court); *Amazonia, Ghosts, The Member of the Wedding* and *Festa!* (Young Vic); *The Fahrenheit Twins* (Told By An Idiot, UK tour & Barbican); *I Ought To Be In Pictures* (Manchester Library); *A Christmas Carol* (Dundee

Rep); *Origins* (Pentabus); Daisy Pulls it off, *Blithe Spirit, Black Comedy* and *Dreams From A Summerhouse* (Watermill); *Once on this Island* (Birmingham/ Nottingham/ Hackney); *Harvest* (UK Tour); *Melody* and *In the Bag* (Traverse); *Aladdin* and *Jack and the Beanstalk* (Hackney Empire); *Mother Courage* (Nottingham Playhouse/ UK tour); *Into the Woods, Macbeth* and *Way Up Stream* (Derby Playhouse); *The Bodies* (Live Theatre Newcastle); *The Morris* (Liverpool Everyman) and *Bread & Butter* (Tricycle).

Opera and Dance includes: *After Dido* (English National Opera/ Young Vic); *Awakening & Another America: Fire* (Sadler's Wells); *Il trittico* (Opera Zuid); *Falstaff* (Grange Park Opera); *Canterville Ghost* (Peacock); *Cavalleria, Rusticana* and *Pagliacci* (Haddo House Opera) and the concert performances of Stravinsky's *Violin Concerto*, George Benjamin's *Dance Figures*, Bartok's *Concerto for Orchestra* and Stravinsky's *Oedipus Rex* (Royal Festival Hall). www.PhilipGladwell.co.uk

FERGUS O'HARE,
SOUND DESIGNER

Most recent work includes: *The Crucible* (Regent's Park); *The Lion's Face* (Opera Group); *Pictures From An Exhibition* (Sadler's Wells); *Peter and Vandy* (503); *All My Sons*

(Curve); *Inherit The Wind* (Old Vic); *The Black Album* (National Theatre); *Much Ado About Nothing, Tempest, Importance of Being Earnest* (Regent's Park); *Julius Caesar* (RSC); *In The Red and Brown Water* (Young Vic); *Alphabetical Order* (Hampstead Theatre); *Twelfth Night* (Donmar West End); *Cordelia Dream* (RSC); *Marble* (Abbey Theatre). Work in New York, Los Angeles and Sydney includes: *The Shape of Things, A Day in the Death of Joe Egg, Dance of Death, Noises Off, Electra* (Drama Desk Nominee) and *An Enemy of the People.*

JASON MOORE, ASSISTANT DIRECTOR

As Director: *Save Your Kisses For Me* (Barons Court Theatre); *Is Your Bag Really Necessary* (Rosemary Branch Theatre); *I Love Paris/New England* (Lost Theatre, New Writing Festival); *Sleeping Beauty* (Bergen, Norway also writer); *A Christmas Carol* (Rosemary Branch Theatre); *The Irish Curse* (The Project Theatre, Dublin). As Assistant Director: *The Orchestra/The Bald Prima Donna* (The New Players Theatre); four plays for The New End Theatre *Halpern and Johnson, Resident Alien, G&I* and *The Hokey Cokey Man; Becoming Marilyn* (Riverside Studios, Edinburgh Festival); *Sleeping Beauty* (Harlequin Theatre); *Dreamers, Tennessee Williams Triple Bill* (Hackney Empire, Studio Theatre); and *Waxing Lyrical* (Rosemary Branch Theatre).

ED WILSON, PRODUCTION MANAGER

Ed graduated from Bretton Hall (1988) and has spent over twenty years working in the theatre industry. Production Manager of The Royal Court 1995-99, where credits included: *Mojo, The Lights, The Leenane Trilogy, Cleansed, The Weir* and *The Chairs,* both also on Broadway. Other credits included the world premiere of *Scrooge* (1992) and Complicite *Street of Crocodiles* (Lincoln Centre Festival). Ed was Technical Director of Theatre Royal Plymouth (2001-4) where he managed many TRP co-productions with the likes of Thelma Holt and Cameron Mackintosh Ltd and BKL. Ed then worked on many West End theatre refurbishment projects for Cameron's Consultants Department (2004-8), did *Aida* (Disney/Stage Entertainment DE) and also worked extensively for Matthew Bourne's New Adventures Company for whom credits include: *Edward Scissorhands, The Car Man, Nutcracker!* (for ATG) and the 2008 EIF hit *Dorian Gray.* More recent shows include: *As You Like It, The Light In The Piazza,* and *Peter Pan* for

Curve Leicester and *Romeo and Juliet* for Ludlow Festival. Ed is currently working on *Zaida* for Classical Opera Company. www.edwilsonproductions.co.uk

LOUISE CHANTAL, PRODUCER

Previous co-productions with Soho Theatre Company include: The Riot Group in *Pugilist Specialist* (First of the Firsts, Herald Angel, and The Stage Acting Award nominees) and *Switch Triptych* (Fringe First winner); Will Eno's monologue *Thom Pain (based on nothing)* – Pulitzer Prize runner-up 2005; Fringe First and Herald Angel Winner 2004; The Stage Acting Awards Best Actor (for James Urbaniak); and *How to Act Around Cops*. General managed The Tiger Lillies' *Seven Deadly Sins* (Edinburgh 2008).

Recent theatre productions include: Footsbarn's *A Midsummer Night's Dream* (Edinburgh Festival and Victoria Park, Tower Hamlets – Total Theatre Award winner) and *The Lady of Burma* (Edinburgh Festival and UK tours, with James Seabright Productions). Productions while Theatre Director at Assembly Theatres include: *The Odd Couple* with Bill Bailey and Alan Davies; the world premiere of touring dance phenomenon *Havana Rumba!;* the world-premiere stage adaptation of *Midnight Cowboy*; the off-Broadway hit *The Exonerated* (Fringe First, Herald Angel and Amnesty Award 2005); Teatr Nowy's *Faust* (Herald Angel Winner, Total Theatre Award nominees) and *Forgotten Voices* (with Matthew Kelly and Belinda Lang). www.chatalarts.co.uk

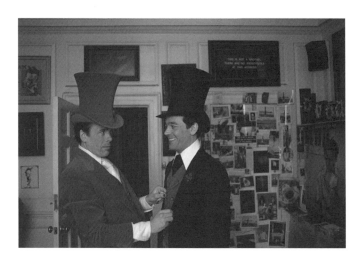

PERFORMANCE PROVOCATIVE AND COMPELLING THEATRE, COMEDY AND CABARET
SOHO CONNECT A THRIVING EDUCATION, COMMUNITY AND OUTREACH PROGRAMME
WRITERS' CENTRE DISCOVERING AND NURTURING NEW WRITERS AND ARTISTS
SOHO THEATRE BAR OPEN UNTIL LATE. TICKETHOLDERS GET 10% OFF SELECTED FOOD AND DRINK

'The invaluable Soho Theatre'
MICHAEL BILLINGTON, THE GUARDIAN

'The capital's centre for daring international drama.'
EVENING STANDARD

'A jewel in the West End'
BBC LONDON

THE TERRACE BAR
Drinks can be taken into the auditorium and are available from the Terrace Bar on the second floor.

SOHO THEATRE ONLINE
Giving you the latest information and previews of upcoming shows, Soho Theatre can be found on facebook, twitter and youtube as well as at sohotheatre.com

EMAIL INFORMATION LIST
For regular programme updates and offers visit sohotheatre.com/mailing

HIRING THE THEATRE
Soho Theatre has a range of rooms and spaces for hire. Please contact the theatre on 020 7287 5060 or go to sohotheatre.com/hires for further details.

Soho Theatre is supported by:
ACE, Bloomberg, John Ellerman Foundation, TEQUILA\London, Westminster City Council, Harold Wyam Wingate Foundation

Performances in the Lorenz Auditorium / Registered Charity No: 267234

SOHO STAFF

Artistic Director: Steve Marmion
Executive Director: Mark Godfrey

BOARD OF DIRECTORS

Nicholas Allott (chair)
Sue Robertson (vice chair)
David Aukin
Oladipo Agboluaje
Norma Heyman
Shappi Khorsandi
Jeremy King
Lynne Kirwin
Neil Mendoza
David Pelham
Carolyn Ward
Roger Wingate

HONORARY PATRONS

Bob Hoskins - President
Peter Brook CBE
Simon Callow
Gurinder Chadha
Sir Richard Eyre CBE

ARTISTIC TEAM

Writers' Centre Director Nina Steiger
Soho Connect Director Suzanne Gorman
Casting Director Nadine Rennie CDG
Producer – Late Night Programme Steve Lock
Writers' Centre Assistant Alix Thorpe
International Associate Paul Sirett
Senior Reader Sarah Elkashef

ADMINISTRATION

General Manager Erin Gavaghan
Assistant to Directors Amanda Joy
Financial Controller Kevin Dunn
Finance Officer Kate Wickens

MARKETING, DEVELOPMENT AND PRESS

Communications Director — Jacqui Gellman
Development Director — Jo Cottrell
Development Consultant — Elizabeth Duducu
Marketing Manager — Nicki Marsh
Press and Public Relations — Fiona McCurdy
(020 7478 0142)
Marketing Assistants — Sarah Madden and Vikki Mizon
Development Assistant — Tristan Bernays
Access Officer — Charlie Swinbourne

BOX OFFICE AND FRONT OF HOUSE

Front of House and Events Manager — Jennifer Dromey
Box Office Supervisor — Natalie Worrall

Box Office Assistants — Danielle Baker, Lou Beere, Amanda Collins, Hannah Cox, Tamsin Flessey, Lynne Forbes, Louise Green, Eniola Jaiyeoba, Helen Matthews, Celia Meiras, Leah Read, Becca Savory, Will Sherriff-Hammond, Dominique Trotter and Tom Webb.

Duty Managers — Julia Haworth, Tara Kane and Martin Murphy.

Front of House staff — Emma Akwafo, Celyn Ebenezer, Aliya Gulamani, John Hewer, Jonathan Hampton, Ian Irvine, Bea Kempton, James Mann, Marta Maroni, Mark McManus, Josipa Percovic, Simon Perry, Hannah Steele, Moj Taylor and Iona Wolff.

PRODUCTION

Technical Manager — Nick Blount
Head of Lighting — Christoph Wagner
Technician — Natalie Smith

21 Dean Street,
London W1D 3NE
sohotheatre.com
Admin 020 7287 5060
Box Office 020 7478 0100

The Soho Theatre Development Campaign

Soho Theatre receives core funding from Arts Council England, London. In order to provide as diverse a programme as possible and expand our audience development and outreach work, we rely upon additional support from trusts, foundations, individuals and businesses.

All of our major sponsors share a common commitment to developing new areas of activity and encouraging creative partnerships between business and the arts. We are immensely grateful for the invaluable support from our sponsors and donors and wish to thank them for their continued commitment.

Soho Theatre has a Friends Scheme in support of its education programme and work developing new writers and reaching new audiences.

To find out how to become a Friend of Soho Theatre, contact the development department on 020 7478 0111, or visit sohotheatre.com.

Principal Sponsors and Education Patrons:

Anonymous
BBC Children in Need
Bloomberg
Capita
John Ellerman Foundation
Esmée Fairbairn Foundation
Financial Express
St. Giles-in-the-Fields Parochial Charities
The Groucho Club
TEQUILA\London
Carolyn Ward
The Harold Hyam Wingate Foundation

In-Kind Sponsors:

Latham & Watkins
Roscolab Ltd

Original paintings included in the stage set:
Sebastian Horsley, *Crucifixion 4*, 2001
Sebastian Horsley, *Flowers of Evil*, 2010

For all enquiries relating to the artworks and the slide show of Sebastian Horsley photo portraits showing in the Soho Theatre bar, please contact Hester Finch at Artists First Management, hester@artistsfirstmanagement.co.uk, +44 (0)20 7759 4989.

This script for *Dandy in the Underworld*
went to print before the end of rehearsals

DANDY IN THE UNDERWORLD

Tim Fountain

DANDY IN THE UNDERWORLD

Based on the book by Sebastian Horsley

OBERON BOOKS
LONDON

First published in 2010 by Oberon Books Ltd
521 Caledonian Road, London N7 9RH
Tel: 020 7607 3637 / Fax: 020 7607 3629
e-mail: info@oberonbooks.com
www.oberonbooks.com

A catalogue record for this book is available from the British
Library.

ISBN: 978-1-84943-114-9

Images of Milo Twomey and Sebastian Horsley by Muir Vidler.

Printed in Great Britain by CPI Antony Rowe, Chippenham.

For Richard and The Dolls

DANDY IN THE UNDERWORLD

By Marc Bolan

Prince of Players, Pawn of none
Born with steel reins on the heart of the Sun
Gypsy explorer of the New Jersey Heights
Exalted companion of cocaine nights
'Cos he's a Dandy in the Underworld
Dandy in the Underworld
When will he come up for air,
Will anybody ever care?
At an old eighteen exiled he was
To the deserted kingdoms of a mythical Oz
Distraction he wanted, to destruction he fell
Now he forever stalks the ancient
Mansions of hell
Now his lovers have left him
And his youth's ill spent
He cries in the dungeons and tries to repent
But change is a monster and changing is hard
So he'll freeze away his summers in his
Underground yard

SEBASTIAN'S STUDIO, 'HORSLEY TOWERS', A FIRST FLOOR FLAT ON MEARD STREET, SOHO, LONDON. PRESENT DAY.

IT IS LATE MORNING. THE ROOM IS IN SEMI-DARKNESS. THE SHUTTERS ARE CLOSED. TINY SHAFTS OF LIGHT SEEP IN THROUH THE CRACKS IN THEM. IN THE HALF-LIGHT WE HEAR A PHONE RING AND THE ANSWER MACHINE KICK IN.

VOICE: *(On machine.)* This is Sebaaaaastian Horsley, please leave me a message after the tone.

VOICE: *(On machine.)* Basti it's John from Henry Oliver tailoring. You still owe me five thousand pounds. You're a cunt.

Sebastian emerges at the bedroom door in the half-light. He lounges against the frame in a silk dressing gown. He holds a glass of milk.

SEB: You didn't need to waste 10p to tell me that dear, I could have called you.

He switches on a little light on his desk and picks up a small clock from his desk and holds it up to see it.

Golly is that the time? Mind you, sleep has always been like death to me but without the long-term commitment. I once spent seventy-two hours asleep in my old flat in Shepherd Market. I was on Heroin at the time but still it was quite an achievement. I'd just read a book by a man called Ernest Becker who argued that everything we did in life was about distancing ourselves from our own inevitable death and that only if we admitted we were just doomed and defecating creatures could we begin to transcend our plight. So I did a crap in the middle of the room and caked it all over myself. I smeared *man* on my stomach and *pig* on the walls and then I put on Beethoven's Ninth and had a good wank. I can't say as it changed my outlook on life much, but to this day I can't buy lavatory paper, I have to send the cleaner out. I sympathise with the Chagga

Tribe for whom the height of fashion is a tight fitting anal plug. They proclaim their superiority by pretending to not to need to defecate. It's tragic that even the Byron's amongst us have to hunker down like a baboon every morning.

Beat.

Speaking of shit, I better get mine together. I'm having lunch at Claridge's at one with a girl called Henrietta from my Austrian publishers. She's as flat chested as a pageboy but there's something about her that's eminently fuckable. I tried to get into her knickers last night – I brought her back here after dinner at the Groucho – and we stayed up 'til all hours discussing the lack of meaning of life – but she wasn't having it. Apparently she's monogamous and has a boyfriend in the Alps. It's difficult to decide which of the two facts is the most disturbing isn't it? Actually it's not. Of all the sexual perversions I find monogamy the most un-natural. In my opinion if you say you are enjoying sex with the same person after a couple of years you're either a liar or you're on something. I mean even though the Ivy serves perfect Shepherds pie it doesn't stop one occasionally craving a visit to the Wolseley does it? Variety is the spice of life after all and love is merely the delusion that one person differs from another. Were I to remain monogamous I would make one woman happy but all the rest of the women in the world unhappy – what right have I to do that? You see I think sex has absolutely nothing to do with morals, it's a compulsion, like murder. I've no doubt Henrietta will succumb to my charms today after a nice plummy Claret.

He notices a scarf on the floor.

Look, she left her scarf.

He picks it up and places it over the back of his throne.

I'll just place it there and then after lunch she can come and collect it.

He goes to the windows and throws back the shutters, light floods in to reveal his full studio in all its glory. There is a desk and chair downstage right. On a wall is a gun mounted on velvet in a picture frame. Downstage left there is his throne. There is a painting upstage centre on an easel and covered in a sheet. Behind it on the back wall is a kind of shrine to St Sebastian. There are hundreds of photographs and pieces of publicity material dedicated to him.

Welcome to the strong sad kingdom of self. *(He laughs at himself.)* I subscribe to the Quentin Crisp school of home decoration: You must have nothing around you that does not express the kind of person you have decided to become. I'm aiming to be a self-absorbed twat – after all it takes so much finesse to fall in love with yourself. But actually I have to be surrounded by my press cuttings if I am to discover who I truly am. I'm a controversial figure. People either dislike me or hate me. This was *The News of the World* when I crucified myself in the Phillipines.

Pointing to a front page of the News of the World pinned on the wall. It reads 'Art freak crucifies himself'.

Jesus died to save humanity. I did it to save my career. In my opinion neither of us had much success. Maybe that was because mine went a little wrong. You see as they raised me up on the cross the foot support collapsed and the whole thing fell forward onto the screaming villagers. They were terribly sweet, they said my hands had been spared because I was an artist. The real explanation was a tad more prosaic. It had been raining in the run up to my crucifixion and the water had weakened the footrest on the cross and as I was a good three or four stone heavier than the average Filipino it collapsed. Bad carpentry was the cause – as Jesus, the carpenter, would probably have well understood. A friend of mine photographed the whole thing and then staged an exhibition. He wanted to call it 'Surrender.' I suggested he title it: 'Is there a God or am I too fat?' It caused quite a fuss though. The Irish church went crazy. Apparently it was a 'blasphemous insult'. Shame they weren't as worried about their priests raping

choir boys. I had to go on the Today programme with John Humphrys to defend myself. He said 'Well, Mr Horsley, you may have been trying to imitate Christ but you didn't die up there did you?' I said 'I am very sorry to disappoint you Mr Humphrys.' I didn't care what they said; at least they were calling me names I liked. But then this female critic declared my paintings 'feeble and conventional' so I went to Tiffany's on Bond Street and obtained one of those beautiful turquoise boxes, came home, shat in it and then had it couriered round to her. When she returned home that evening she found an exquisite little gift on her front doorstep. Of course being a humourless bitch she took it to the police but I had my defense prepared. I declared it an artwork: 'The Shit Has Hit The Foe'. She was a critic. I was an artist. I could take art, could she could take criticism? I know you are supposed to turn the other cheek but I decided to part them instead. Nowadays I try to not to let people's reactions affect me. I have made my heart a sanctuary into which the only person who can enter is moi. Let us see if we have received any communication from the outer world.

We hear the sound of an email arriving. He looks at the screen of his laptop.

There's an email from my German publisher saying that they still find the introduction to the German edition of my 'unauthorised autobiography' offensive. Oh dear. All I said was that I was amazed the Krauts had made Hitler – an Austrian – their poster boy and did it mean that I, a boy from Hull, stood a chance of succeeding him? Well I too commit atrocities in showers, but usually with a bottle of Radox and an Iranian hooker. Maybe I should re-title it Mein Camp? Mind you, their reaction is nothing. The Americans wouldn't even let me in their country to publicize the book, I was refused entry at JFK and sent back to Britain on grounds of 'moral turpitude'. America has seen such a scandalous flurry of fictitious autobiographies that I suppose I should have been relieved

that they thought mine to be factual. The little man in
the box said 'Have you ever used or been involved with
illicit substances?' I said 'The only illicit substance I know
is couscous'. He said 'you know what I mean'. I said
'Oh you mean drugs? – then I paused for dramatic effect
– 'Yes and proud of it.' Then he said 'Have you ever
solicited prostitution?' I said 'Yes. Mary Magdalene set a
saintly precedent.' He said 'Who is Mary Magdalene?' I
didn't bother to answer that. Then finally he said 'And
what have you got in that hat?' I said 'My head'. That
seemed to tip him over the edge and I was swiftly charged
and deported. Land of the free, indeed. I didn't mind
really. As I said to someone on the plane on the way
back 'I only write to get my knob sucked'. The problem
is most of the girls I am attracted to are illiterate. What
else is there in my little virtual in-tray? A missive from
my tailor threatening to take me to court for the unpaid
tailoring bills. Cheeky devil, I was only at his book launch
in the week. I know. Can you imagine a tailor writing a
book? How impertinent. I don't want a tailor who thinks
he is as much a star as me. I would never wear a famous
tailor's clothes. When I walk in to a room I want people
to say 'There is Sebastian Horsley.' I don't want them
saying 'There's Ozwald Fucking Boeteng'. Nothing against
Ozwald Fucking Boeteng you understand. I just don't think
a tailor should bespeak unless he bespoken to. What else
is there? An offer to help me 'build my own conservatory',
'News of exciting developments in erectile dysfunction',
oh and an invite to appear in a televised round table
discussion on anal sex at the ICA on Friday 13th – there
isn't a fee as such but apparently they do supply 'a splendid
hot supper afterwards.' And people who commit suicide
say things like 'I'd nothing to live for'. Nothing from
Henrietta, the fuck's obviously still on. You know she was
on about me doing some television last night. Apparently
she has a half brother who runs a TV company here in
London and she thinks he might be interested in making
a documentary about my extraordinarily happy life for

BBC Four. I said to her 'are you sure it's what the viewers of BBC Four really want to see?' but she was adamant that they did. Apparently 'Extreme ways of living have much to teach us about normality'. I can't say I've ever learned much from my life and I've lived it. In fact the only real progress I seem to have made is in my ability to laugh at how ludicrous I am. I've recorded quite a number of little things on camera recently. They are on YouTube. There's 'Sebastian Horsley's guide to happiness', 'Sebastian Horsley's guide to drugs' and 'Sebastian Horsley's guide to whoring'. I think she was little taken aback about my use of prostitutes. She said 'I've just finished re-reading your book'. I said 'well done, even I've only read it once'. Then she said 'Have you really slept with a thousand prostitutes?' I said 'Yes'. She said 'Why?' I said 'why not?' That's the marvellous thing about living in Soho. You're never more than three feet from a prostitute or a photographer – sometimes you can get both at the same time – touched up without the aid of Photoshop. I told her I've slept with every sort of girl in every sort of position and in every sort of country and I never tire of them. They are the most honest people on God's earth: 'Lust, bitterness, nullity of human relations, muscular frenzy and the ringing of gold' as Monsieur Flaubert said.

Picking up his enormous top hat from where he left it last night.

You see I'm a dandy and for a dandy whores aren't what they are for most bores – a substitute for regular women. It's regular women that are a substitute – and a poor one – for prostitutes. I remember the first time I had real sex – I still have the receipt. Normal sex leads to kissing and before you know it you have to talk, and once you know someone that well the last thing you are going to want to do is screw them. Or breed with them – the only place a dandy should be seen pushing a pram is into the Thames. Besides I never trust anyone who says their love is going to last longer than a weekend. I prefer lust over love,

sensation over security – and the chance to fall into a woman's arms without falling into her hands.

Beat.

Excuse me I need to run some water over my features.

He goes into the bedroom/bathroom. We hear a shower come on.

(Off, shouting over the sound of the running water.) But seriously though it does makes me laugh when men talk about prostitutes and they say 'I've never had to pay for it'. It's like they value money more than sex. Sex with a prostitute is the purest transaction a man can have, the sensation of sex, without the boredom of its conveyance. In a brothel you can buy physical closeness without the intervention of personality. You can use money, the most impersonal instrument of intimacy to buy the most personal act of intimacy. With normal women, a kiss is usually an application on the top floor for a job in the basement. With whores the basement is permanently let but the top floor is locked. *(Returning, with a towel around his waist, towelling himself dry.)* Besides normal sex hasn't been the same since women started to enjoy it. I love hookers so much I sometimes rent my bedroom out to them. I don't do it for the money – I think it's vulgar to do things for money – especially when you haven't got any. No, as they say in lesbian detective novels, I have ulterior motives: My secret spy-hole.

He pulls a post-it note from over a spy hole at the side of his desk. He peers through it. It gives him a clear view of the bedroom.

What is privacy for if not for invading? Voyeurism is a healthy non-participatory sexual activity. The world should look at the world. When one looks through a keyhole almost anything has an air of sordid mystery. I've loved spying ever since I was a boy and I drilled a hole in my sister's bedroom door. It was marvelous. I made a little putty plug and covered it with a picture of myself and in the evenings, I would remove my image and masturbate

furiously whilst looking at my sister's friends or sister herself if she wasn't entertaining. One night I crept into her room when she was asleep and masturbated directly over her – well she did have great tits. Sadly just as I was just about to come she woke up. Luckily it didn't phase her. The next morning at breakfast she told me she thought I had been 'sleep walking' and 'blowing' on her.

He exits into the bedroom.

(Off.) Nowadays I just watch my prostitutes, I don't join in; too many cocks spoil the brothel.

Returning in a different silk dressing gown

I did a couple of years on the game myself. Here's my card.

He takes his card from his shrine.

'L'Homme, high class male escorts/chaperones for discerning ladies who deserve nothing less than the best'. I found the agency in the back of a soft porn magazine; it was run from Leicester by two women called Cheryl and Rio. Cheryl wrote those Black Lace novels that dally about with women's bits in the boudoir. 'We're relaunching' she said. 'We'd like you to come for a photo shoot. You are going to be our poster boy, the public face of our enterprise, our flagship.' This was consoling; it's nice to be in the same boat as one's betters – especially if it's sinking. It was hilarious, within a few weeks I was appearing in quarter page ads at the back of OK Magazine. The problem was the first point of contact for clients with me was the telephony. And as you will probably have noticed by now I have the voice of a lobotomised, homosexual drug addict who has decided to keep his head in a bucket. But then I answered this one time and somehow got myself booked. The lady lived in Camberley, in a house policed by two stone composite lions, and drank Campari and lemonade. She wanted to take me to a swimming pool party to pose as her latest beau in front of her ex-husband.

I said 'fine, posing is the only job I can actually do'. For a while I really enjoyed being a 'rent man'; sex like all games of chance is better played for money and I took the view that if someone wanted my body more than I did, they could have the damn thing. After all I didn't care for it much myself. I have never gone to the gym, or entangled myself in yoga, or succumbed to any other such corporeal diseases that rot the soul. The only function of my body is as far as I am concerned, to carry my beautiful face around. It's merely a pedestal for my head. But gradually the clientele went down hill. There was a keep fit fanatic in Notting Hill who was so thin and flat chested that if she'd had two more navels I could have turned her into a flute. There was a Home Counties sounding woman who wore an alpaca sweater! God she was a dog. She kept worrying about the condom bursting. I was more worried about rabies than babies. And then there was my Waterloo. I got a call from the chef at The Windows On The World restaurant at the top of the Park Lane Hilton. He was vast and pallid and had the sort of corn coloured hair in which it looks as though someone had started to cut a crop circle but failed to finish. Over a dinner of calves' liver, supplied by his restaurant, he said 'I want you to fuck the wife whilst I watch'. I had no problem with this nor with the £500 that came in a brown envelope – my virtue can withstand anything except the highest bidder. But then I met The Wife. Joan had evidently swallowed a whale and had a face that launched a thousand dredgers. I had a kind of outer body experience. I remember floating above the dinner table, looking down at the rotting corpse of my life. My appetite for depravity had finally sickened upon what it had fed. I had wanted to sell my body to get rid of it but I had found that a man cannot get rid of his body, even if he throws it away. Excuse me I have to dress.

He goes into the bedroom and returns pushing a large antique clothes rail on wheels with lots of suits carefully protected by identical plastic covers.

Tidiness has always been my vice; it's the one thing that prevents me from becoming truly chic. Will Self once came to my old flat in Shepherd Market and we spent all night taking drugs and as the dawn broke around my boudoir he said 'Christ Sebastian I feel like I've died and gone to a dry cleaners'. Strange man, face like a bag of genitals. But you see I can't take any chances. Some of these suits cost ten thousand pounds each and I can't afford to replace them now I'm a desperate dandy. When I bought these I was a millionaire, but once you start spending a hundred grand a year on prostitutes and crack cocaine it soon goes.

He starts to obsessively count the suits.

(To himself.) One-two-three-four-five-six-seven-eight-nine-ten-eleven-twelve-thirteen-fourteen-fifteen-sixteen-seventeen-eighteen- nineteen-twenty-twenty-one-twenty-two....*(To us.)* I'm sorry I have an obsessive-compulsive problem. I go into a complete meltdown if the kettle is not facing due east every morning *(To himself.)* One-two-three-four-five-six, seven-eight-nine-ten-eleven-twelve, thirteen-fourteen-fifteen-sixteen-seventeen-eighteen, nineteen-twenty-twenty-one-twenty-two-twenty- three-twenty four, twenty-five-twenty-six-twenty-seven-twenty-eight-twenty-nine-thirty. Oh god why isn't someone here with me? *(To us.)* If I get someone else to count them it breaks the spell. *(To himself again.)* One-two-three-four-five-six, seven-eight-nine-ten-eleven-twelve, thirteen-fourteen-fifteen-sixteen-seventeen-eighteen, nineteen-twenty-twenty-one-twenty-two-twenty- three-twenty four, twenty-five-twenty-six-twenty-seven-twenty-eight-twenty-nine-thirty.*(To us.)* Sorry about that, one of my little quirks that makes my life such a delight to live. I've had it since I was at boarding school – then all my work had to be underlined with red ink or my girlfriend would leave me. It's a crazy illness, very difficult to understand for the non-sufferer. The best explanation of it I've heard was the story of a train passenger who spent an entire journey from London to Bristol tearing his

newspaper into small pieces which he then threw out of the window. A fellow passenger apparently said 'why do you keep doing that?' he said 'because it keeps the tigers away'. The passenger said 'but there are no tigers'. And then the gentlemen said 'I know, wonderfully effective isn't it'. OCD is like petitions of prayer where you try to manipulate the result and prayers are to men what dolls are to children, they are not without use and comfort but they should not be taken too seriously. Now what should I wear for my luncheon? My christening suit?

Taking the wrapper off a remarkable suit and holding it up.

My wedding suit?

Takes the wrapper off another.

Or my funeral suit?

He reveals an utterly outrageous multi-coloured sequinned number.

My wedding suit I think. I bought most of these when I returned to London from Scotland. I had to get new outfits because whilst in Edinburgh a pink suit had the power to make even the most affable yob throw a fish supper at me in my open topped Rolls, in London it was merely accepted. I was standing around on street corners causing absolutely no sensation at all. This would not do. A man with no talent has to have a great tailor.

He holds a suit up.

I chose mine from the most exclusive list. There was Mr Khan of Huntsman fame (and offensive flattery – I blame him for the prawn cocktail pink suede).

Holding up another.

Mr Powell the Soho spiv,

Pointing out another.

Mr Pearse the Soho snob,

Pointing out a final one.

Oh and finally I went to Mr Edie, for leisurewear. I
bought 69 suits in all – one needs to be prepared for
all permutations. I tried out every cut of jacket; single
breasted, double-breasted, big breasted, drape jacket, box
jacket, straitjacket. And I had a special pocket sewn into
each one to accommodate my heroin syringes. Colour and
pattern wise I bought herringbone, hounds tooth, dogtooth,
tartan, chalk stripe, pin stripe, Prince of Wales, prince of
darkness, polka dot. I bought every colour except green,
as I don't go to the country. I also bought silk ties, which
were terrifyingly expensive even when I started to wear
them round my arms rather than my neck. Oh and there
were scarves too. My favourite was rabbit – though I'd
don any fur – in my opinion an animal should be delicious
and fit well. I commissioned four thousand pound shoes
from Lobb. High altitude platforms that made me six foot
nine – but I was well worth the climb. I bought the softest
kidskin gloves – I'm going to wear those today – there's
nothing a lady likes more than the slipping off of a kidskin
glove – but my favourite things were of course were my
shirts from Turnbull and Asser: Shirt makers to the shirt
lifters. Liberace, Skirt Bogarde, Sir John Gielgud and me.
Not necessarily in order of importance. It is upon the
parchment of Turnbull and Asser's sacred tomes that my
great legacy is recorded: The Horsley shirt. Four button
cuff. Five inch turn back. Collar point: five inches – wide
enough to fly. But it will be the buttons I am remembered
by – the covered buttons to be precise. There is something
so rude about a naked button. I am the only male customer
to have ever insisted upon covered fastenings for his shirt.
I even had diamanté on the cuffs and engraved silver
stays. Some dimwit once said 'There's no point' instantly
reassuring me that was *precisely the point.* Hats of course
are the crowning glory of a dandy. Beau Brummell and
Byron went to Locks and so did I. Four fur fedoras. Fur
felt, antelope velour, grosgrain band and bow with feather
mount, satin lining and roan leather. Few things look more

ridiculous than a hat on a man who doesn't suit hats and
nothing looks more ridiculous than an ivory White fedora
on a man who doesn't suit hats, which is why I wore one. I
spent over £100,000 on my wardrobe. I simply had to
squander oodles of money as fast as I hadn't earned it so as
to escape the tortures of having to do something sensible
with it. Once I had tired of a Huntsman special I would
wear them as painting overalls. From Savile Row to B
and Q with nothing in between. I think the drugs had a
part to play in that. When I was using I didn't care about
my clothes. I once sold £20,000 worth of suits for three
hundred quid to a man from Billy Smart's circus who was
re-costuming the clowns.

Looks out the window.

Talking of drugs the smack dealers out on Meard Street.
For some reason he still hangs around outside my door
even though I haven't bought anything from him for an
age. Heroin's like the whore who gave you the best fuck
you ever had. She may have stolen your credit card and
given you clap but a part of you always feels like going
back for more. The fixing ritual is one of the sweetest
pleasures known to man. The only problem is the dealers
end up stealing your life. In the case of my last crack
dealer, English – quite literally. It was hilarious. When
he first came to me he drove a Nissan Micra and wore
a baseball cap swiveled backwards. I used to say to him
'English, please if you are going to deliver me five hundred
pounds of crack cocaine you could at least dress for the
occasion'. But by the end of our time together he was
driving a BMW and wearing smart suits and I was the
one who looked like a tramp. Then to add insult to injury
he took up art. He turned up one day and said 'I've got
something for you'. I said 'I know – now give it to me'.
But instead of spitting out a little cellophane package
he unraveled some sketches he'd done. It was as if he'd
gone to the fancy dress shop and asked for the Sebastian
Horsley. William Blake said 'the road of excess leads to

the palace of wisdom' which was rather naughty of him because it doesn't, I just sat in a darkened room for six months masturbating to *Home and Away*. I've no regrets though. If I had my time again I'd take the same drugs only sooner and more of them. I better sally forth and dazzle.

Revealing the red velvet suit.

I think this one is suitable for lunch at Claridge's don't you?

He starts to ritually lay out his clothes on his throne. They look like a person.

I've always been fascinated with dressing up. When I was a child I would put on my mother's clothes and make-up and pretend to be Marc Bolan. I'd steal into her room and drape myself in her black feather boa, slide on her pink silk gloves and paint myself with her brightest red lipstick. Then I'd copy her, I'd rub my lips together, pursing and pouting in the mirror. To most children there is a difference in degree between their imaginary and real lives – the one being more fluid, freer and more beautiful than the other. To me fantasy and reality were not merely different; they were opposed. In one I was Marc or some other exotic, disdainful woman, and in the other I was just a boy. A boy forced to live in the real world, which I didn't much care for.

Puts on his shirt.

You see my parents were self-made multi-millionaire socialist alcoholics who hated each other. If someone were to set up a production in which Bette Davis was directed by Roman Polanski it could not express the full pent up violence of a single day in the life of my family. On a morning I would come down, after one of their end-of-the world parties and find Mother and Father broken by booze. They lay among their bottles like convicts among their chains. Then my grandmother would tiptoe amongst

them and collect all the empties and wheel them in a pram down the hill into the village of Etton, distributing them on the doorsteps of different cottages. 'Well we can't have the dustbin man knowing our business can we?' All the people who should have been vertical in my life were horizontal. My Mother only got out of bed for funerals and to visit the off licence. In fact she crashed the Jaguar so many times going there that my Father eventually took the keys off her. But that didn't deter her. She simply mounted the ride on lawn mower and drove that into Hull. Sadly it stalled outside Threshers.

Starts to tie his tie.

If life is really only theatre my mother understood that it was mostly cheap melodrama. She was a performance in search of an audience. I remember one night her dressing for the opera with great care in the mirror in front of me and then she turned to the nanny and demanded that one of the children accompany her. The nanny said 'Which one?' And mother replied 'I don't care, whichever one goes with red velvet'. Naturally it was me. Mother always said Madame Verlaine had the right idea about children because she kept her two still born ones in a pickling jar in the bedroom, 'children should be seen but not heard'. She was always death obsessed. When we were young she loved nothing more than to stand behind us as we watched old black and white films on the TV and tell us how the actors had died. 'Ooh that's Jane Mansfield, do you know how she died? Decapitated with her *children* in the back of the car!' 'That's Kay Kendall – she died of cancer, *horribly,* and Linda Darnel, she burned to death after falling asleep with a cigarette. I'd hate to burn to death, you'd look so terrible afterwards wouldn't you children?'. Of course suicides were her favourite, particularly George Sanders: 'he left a suicide note saying God I'm so bored'. They tried all kinds of treatment on her; electric shock – after which she was often quite perky and Mandrax – after which she'd wander round the house like a tortoise on

a lettuce hunt, but nothing worked. Eventually she was admitted to a psychiatric hospital, but she was thrown out for depressing the other patients. Years later I remember her coming to visit me in a drugs clinic. I was lying in bed withdrawing savagely from crack and heroin and she waltzed in looking like a fruit cart, perched on the end of the bed and said 'Have I failed you as a mother Sylvester?' I said 'it's Sebastian, Mother.'

Finally knots his tie. He points out a photograph on the back wall.

This is a photograph of my family taken when I was a child. There's Mother on the floor, face down in her own vomit. That's her mother Gogo, on the sofa with her wig awry and her lipstick skid marked across her face and next to her, look, my Father – his drink in one hand, his cock in the other. The reality was probably that their relationship had exhausted all of its possibilities and one of them should have whipped out a scarf, preferably silk, and flapped goodbye. But human beings are rarely able to arrive at such a philosophical point without destroying everything around them first are they? So instead they took lovers by their dozens. A golden wedding in my family meant you'd just got married for the fiftieth time. One evening my Father fucked my Mother's best friend Janet in front of me while they were swimming in the Med. I watched them sucking and fumbling at each other like a brace of sea slugs. Another time he tried to seduce Mother's sister-in-law (conveniently for him she was ill and bed bound upstairs.). Drinking when he wasn't thirsty and screwing regardless of the season – that was all there was to distinguish Father from the other mammals. He was so absurd – a brilliant businessman who ran a two billion pound business called Northern Foods which sold pork pies to Marks and Spencer but who really wanted to be Allen Ginsberg. *(As Father, in Northern accent.)* 'I saw the best minds of my generation destroyed by madness, starving hysterical naked, dragging themselves through

the negro streets at dawn looking for an angry fix!' He was a drunk and a cripple and the only thing I have to be grateful to him for is that he broadened my emotional range – I never thought it possible to want to murder a drunk cripple. It's no wonder Mother attempted suicide on numerous occasions. She even tried it when she found out she was pregnant with me. I think if she'd known I'd turn out like this she'd have taken cyanide. Years later, after I'd escaped my marriage I had a pop. I've always maintained it's easier to die for a woman than live with her. Sadly I was no better at it than my Mother and ended up face down in a Scottish quarry. We are clearly destined to be a family of failed suicides which is really rather unstylish. I once introduced the Glasgow gangster Jimmy Boyle to my family. He was meant to be begging money for his Gateway project for young offenders. Unfortunately he got pissed at dinner, tried it on with my Mother and then said to me 'I've got a fucking hard on, I'm tempted to 'ave a wank, nah fuck it I'll do you instead'. The next morning when I awoke the birds were singing in the trees and a mass murderer was buggering me in my Father's bed. I had committed symbolic parricide whilst dithering about the real one. I still remember going to see him on his death bed. 'Have a nice life' were his last words to me. In fact they were his first words to me for years. I didn't go to his funeral, but of course I marked the morning of the service. I rose and attired. I decided on pink gabardine with magenta and diamante tie to match. By the time I was finished my look was like Wagner – only louder. Nothing grave about that. My only concession to misery was hidden – my heart was black. You see I was actually in mourning – because I wasn't in the will. Sometimes I fantasise about moving back to Hull. Failure is much less apparent in the provinces isn't it? To be a failure in London is to starve to death outside a banqueting hall with the delicate aroma of an exquisitely cooked dinner entwining your dying breath. Thankfully I have my clothes.

He holds his suit jacket to him almost like it's another person. Then he puts it on.

The key is to dress in a style that would attract attention at a Liberace concert. He was a homosexual you know? A lot of people think I'm queer because of my clothes but I'm not – I just help them out occasionally. I always think it was very naughty of God to put the chocolate machine so close to the playground don't you? Especially as in my case the difference between heterosex and homosex is about two bottles of wine or one pipe of crack. Least it was with Hugo Guinness. God he was marvelous. He was vain, selfish, amoral and weak, and this was not all that I loved about him. He was so empty of content and so content with his emptiness. For two years we flounced around London together high on crack. It was like Brideshead Revisited except I was Sebastian without the house and he was Charles with it and the sex was always interesting. One afternoon, after we had been smoking crack, he pulled his belt from its loops in a single deft movement and said 'Basti your backside is aching for the lash. Bend over' and then he led me to the toilet and made me put my head in the bowl and lick it whilst he beat me. Another evening he hovered into view naked brandishing a rather large cucumber and said 'Basti, darling, din dins, cue come ber time.' He then positioned himself in front of the mirror and had me ram it up him. We were a fabulous couple. We slept every night, all wrapped around each other like hibernating rattlesnakes. I dreamt of dying with him, a senile delinquent after a lifetime of defeat. But then he met this girl who designed wallpaper and loved nature, cooking and tidying and he stopped seeing me. Men may show some discrimination about who they sleep with but they will marry anybody. They had a big wedding and the only person in London that they didn't invite was me. I envy queers – all that casual sex for free. I just don't for the life of me understand why they want to get married – glamour is far more important than equality. Mind you not all of

them are glamorous are they? Some of my queer friends wear clothes that are far too small for them.

He sits in the window and starts to paint his face.

I've borrowed most of my style from the Regency period. My favourite. An era that swung between extreme elegance and sodden brutality, excess and exoticism, when the ruling class blazed, cracked and fizzed in a torrid indian summer before the dismal winter of democracy descended. It was marvellous, gentleman were having their shoelaces ironed whilst children were sweeping their chimney. Wilberforce was denouncing the slave trade while Beau Brummell was denouncing the imperfect cravate. It's funny Henrietta thought he'd be a hero of mine but I told her he wasn't at all. In fact he was so refined that I don't regard him as a real dandy at all. 'If someone looks at you then you are not well dressed' Mr Brummell tells us. But then he would say that as he was so prissily precise that he was essentially a conformist. True dandyism is rebellious. The real dandy wants to make people look, be shocked by and even a little scared by the subversion that his clothes stand for. Being a dandy is a condition rather than a profession. It is a defence against suffering and a celebration of life. It is not fashion, wealth, learning or beauty. It is a shield and a sword and a crown – all pulled out of the dressing up box in the attic of the imagination.

He stares at himself in his little mirror as he continues to apply makeup.

Mr Brummell wasn't even witty, his most famous remark was to refer to the Prince Regent as 'my fat friend'. I mean please. It was only his ending that truly became him. I believe how a man dies shows his true character as much as how he lives. Mr Brummell spent his last days in poverty, in squalor and in France. It's difficult to decide which of these conditions is the most deplorable. But strangely when I read about this I was moved. His posing had come from the heart. An artificial heart, but a heart

none the less. A mass of contradictions he was obviously vulnerable under stress. Stripped of his self-image, clearly he was nothing. The personality he had so painstakingly constructed fell apart. He ended his life slobbering in an asylum with syphilis. Whichever way, the rebel always crumbles into his own ruins.

He starts to paint his nails bright purple.

I don't intend to crumble – well at least not before I've had my lunch with Henrietta anyway. She is a rather remarkable creature. She looks like she's been cut'n' pasted from another era. Last night after she'd refused to sleep with me I went to the brothel to try and fuck her out of my head, but as I was waiting to go in and see the whore I ended up writing her a poem and emailing it to her at 4am. Maybe it'll make her realise how much more exciting life with me would be in the city than marriage to some dullard in the Alps. Maybe she'll decide to stay here and make this documentary about me and we'll embark on some crazy doomed love affair like Sid and Nancy – though obviously she'd have to be Sid. Someone else once tried to get a documentary off the ground about me but it was scuppered by Alcoholics Anonymous.

Continues painting his nails.

The producer said 'we'd like to make a film about you' and I said 'but I don't *do* anything' and he said 'we just want to film an average day in your life'. Well in those days an average day centred around my visit to AA. So I went to the Mayfair meeting – there were the usual Taras and Tamaras rambling on about their sad rich little lives – and I waited to the end. Then when they'd read out the last of the 'Twelve Traditions' the one about anonymity being the spiritual foundation of all they do – 'Who you see here, what you hear here, when you leave here – let it stay here.' – I said 'I'm Sebastian and I'm an alcoholic, a film company is making a programme about me and I was wondering if it would be acceptable to bring them along

to film the proceedings?' The entire room looked at me as
if I had just dribbled sherry trifle in front of them. So I just
picked up my top hat and my mink stole and walked out
never to return. I think it's far worse to be anonymous than
alcoholic.

Holds his nails up to dry

I've never had a lot of luck when it comes to therapy. Even
my analyst fired me. She said 'you have to believe in a
power greater than yourself.' I said 'but there isn't one.'
She said 'Your Father is an alcoholic cripple, your Mother
is an alcoholic who attempted suicide four times, your
Grandmother committed suicide having spent half her life
in an asylum, do you not think this might have influenced
you?' I said 'This is like a really easy game show where
the correct answer to every question is 'Because of my
mother and father'. You know it is so frightfully common
to be loved by one's parents. Of course she didn't give
up. She said 'But you attempted suicide'. I said 'yes but
I failed'. Then she said 'what about the next time?' I said
'there won't be a next time, darling, I'm too unhappy to try
again'. Eventually she said 'the key is finding loveliness in
little things'. About a year later she changed her mind and
as she shook my hand for the last time she said 'perhaps
life isn't for everyone'. I said 'quite'. Psychiatry must be
the only business in which the customer is always wrong.
If you enjoy being made to feel inadequate why not just
call one of your family? Besides I don't think there's any
form of treatment for family life this side of the grave.

Stands by the painting.

I wonder if I should take the sheet off my painting so
Henrietta can see my work? I kept it hidden last night for
fear it put her off. It does happen – my paintings aren't
what you'd term popular. I was once burgled and they
took everything; the kettle, some old socks, even a broken
sandwich toaster, but they didn't touch my art. This one
is part of a triptych I've been commissioned to do for the

upstairs dining room of the Ivy restaurant. I hope they like it. The last thing I sold them was a series of hypodermics in boxes for the Ivy Club. I thought it was quite witty – I.V! This is just my usual sunflowers. I've been obsessed with them since I was a child In High Hall. I would spend hours by myself planting them every year, a monstrous regiment ranked against the wall of the barn. I always identified with the sunflower. I had an instinct for its sudden, fantastic radiance and its equally sudden collapse. Maybe, even then, I sensed in it an emblem of our own lives. I try and paint them as leaping demons, like serpents casting themselves upon their prey. To capture the carnage that coils inside creation, the violence that seethes below every surface. The sunflower has no ordinary self, dressed as it always is in dandy clothes. Do you want to see my picture? I've suffered for my art, now it's your turn.

He takes the sheet off to reveal the painting. It is rampant sunflowers.

I've painted hundreds of them – not that it's ever done me much good financially. I've staged two shows in London in ten years and earned the princely sum of ten thousand nine hundred and seventy-six pounds and fifty-four pence. I always said I wanted to earn a little money from my art and that's exactly what I've done. Fortunately art is the only profession where no one considers you ridiculous if you don't earn any money. I probably should have packed in years ago but life is only a game – and everyone loses so why not just go on gambling anyway, maybe the Gods will eventually decide to favour me?

The doorbell goes.

That will be her!

He puts his enormous top Hat on.

You know I once caught my cleaner trying to steal this hat. I said 'what are you doing leaving with my hat?' and she

said 'I thought you had given it to me'. I'd no idea she had such a strange idea of herself.

He looks at himself in the mirror. He looks extraordinary.

God I'm a vain bastard. Take note: For the ultimate first date with me wear a full length mirror and say nothing.

The doorbell goes again. The peacock draws himself to his full height.

Excuse me, I have to take a gorgeous flat chested Austrian to Claridge's.

SEBASTIAN exits. We hear footsteps down the stairs and him open the front door of the building. We hear a rather loud exchange. It is impossible to work out exactly what is being said but it culminates in SEBASTIAN being heard to say loudly..

SEB: *(Off.)* Piss off!

He slams the door shut and climbs back up the stairs and re-enters the studio.

SEB: It wasn't her! It was one of my prostitutes wanting to use the room. She was with this perfectly hideous drunken Scottish man. He said 'alright mate' to me! I said 'I've never been alright in my life' and I'm no-one's mate – least of all a man in jeans. There are two things I cannot tolerate, the first is murder and the second is denim.

Looking out the window at the man who is still there arguing with the hooker.

Come to think of it I'm not very keen on the Scots either. Miserable cunts. Well they are, forever bleating on about how the English get a much better deal than they do.

Opens window.

Shut the fuck up you tartan cunt!

Closes window.

God they love whining. I got so sick of them complaining to me when I lived there that I took to driving up the Lothian Road on a Saturday night in my red Rolls Royce to wind them up even more. It was the most marvellous lightning conductor of local resentment. It was scratched, spat on, sworn at. Once, all four hub-caps (bespoked chrome.) were stolen. Each would have cost as much as an Edinburgh council house. Another time a wheelbarrow was lobbed through her windscreen (odd what those gnomish little Scots like to trundle about with isn't it?). But I had the most fun in the one week of Scottish Summer. Then I'd take the top down and the missiles would really fly, beer cans, old shoes, copies of The Scotsman. Once an uneaten fish supper landed beside me. I stared impassively ahead. It didn't smell any worse than some of the girls who had sat there (though it was rather better dressed). Besides, when people attack them, those with charisma always look like they don't have a care in the world. Sometimes I'd up the ante even more and pull over and ask for directions. The window would make its imperial descent and then I would say something like 'Excuse me sir but could you tell me the way to the castle?' and the tartan man would reply 'Git tae fuck, yir radge English cunt.' And I'd say 'Oh, thank you, my good man.' And then wind the window back up. Finally I got a chauffeur to really seal the deal – well I needed staff, as I reminded them, this wasn't a car it was a stately home on wheels. God, Scotland's a shit hole. The weather was so cold I had to get married. It's true, the climate is so abysmal that you only know it's Summer because the rain gets warmer. I think the weather forecast is actually a recording made in the 1930's that no one has had occasion to change: 'drizzle, drizzle, drizzle'.

Looking out of the window.

It's coming on to rain here now. Where is this girl? I can't bare lateness, it brings me out in OCD hives. I'm sure she'd have called or e mailed if she wasn't coming wouldn't she?

Checks emails again.

Nothing. I better call Claridge's and tell them we're going to be late.

He calls.

Hello this is Sebaaaastian Horsley – Whore but without the W – that's right I have a table booked for 1pm and I'm afraid we are running rather late, but we *are* on our way and I just wanted to let you know. Bless you my dear. Goodbye.

He hangs up.

They are always terribly kind to me at Claridge's even though what I spend there nowadays wouldn't keep the toilet attendant in bread rolls. Not that one should keep a toilet attendant in bread rolls.

Checks the phone is in the cradle.

Maybe I offended her with my poem last night? I know she is engaged to be married but why should that stop us?

He takes the poem out of the desk drawer, looks at it. The phone rings.

Here we go – this will be her telling me she's running late because she's spent too much time getting ready.

He answers.

Sebaaastian Horsley. Oh. Not this afternoon darling I'm going out, to Claridge's. Yes it will be lovely for me won't it? I should be here tomorrow morning, try me then. No, try me then! Goodbye.

He hangs up.

Honestly, they treat this place like a knocking shop!

Beat.

Where the fuck is she? I wish I had a mobile number for her. I suppose I could send her an e-mail, she'll doubtless have one of those Blueberry devices.

He types.

'Darling Henrietta I know you could do better but suicide or Claridge's – which is it to be? Love Sebastian.'

He counts keys in an OCD-like way.

The doorbell goes.

About fucking time!

The doorbell goes again.

Keep your knickers on! For now.

Puts his hat on and heads for the door.

How do I look? Stunning – I know. Excuse me.

He exits down the stairs and opens the door to the outside world.

(Off.) Oh, thankyou.

We hear the door close and his footsteps as he climbs the stairs back to the room. He re-enters carrying a large bunch of sunflowers with a card attached.

It wasn't her. It was a homosexual flower boy who'd been stuck in traffic in Notting Hill. Though quite why he shared that hideous detail with me I've no idea. Who the hell has sent me these?

He takes the card from the flowers, opens it. He reads.

Dear Sebastian,
I am terribly sorry I won't be able to meet you for lunch today. But I have decided to take the earlier airplane back to Vienna. I had a great time last night, with you, and I really would have liked to see you more and again, but I think it's better I don't. Do that. I think it's better for me to take the early airplane. It's because, and you know this, I

have said this, it's because I am a fiancée. I am promised to someone else. That is how it is. And just in case you say that this doesn't disturb you, I have to tell you that I am – in the pit of my heart – a traditional woman. There is no avoiding myself. So Sebastian, thinking of this, what I just explained, when you come to Austria next month it's likely a better idea if someone else, someone not me, from the publishing firm leads you on. Forward. You really are, as we say: 'a super typ'(this means: a really fine piece of the male species), but unfortunately I know that if we throw ourselves into a stormy affair it will end in tears, likely my tears, because of my foreboded wedding. I am very sorry and I give you the farewell in friendship.

LG (Lovely Greetings.)

Me x

P.S. Thank you for your smashing poem.

He puts the flowers down.

Foreboded fucking wedding! It sounds like a Hammer Horror film! 'The Foreboded wedding'. Jesus Christ, another one molested by matrimony! What is wrong with people? Before she knows it she'll have dropped a couple of sprogs and she'll be spending weekends with the in-laws in Salzburg and she won't be able to publish books about interesting people like me, she'll be forced to peddle translations of Laurence Llewelyn Bowen just to pay the school fees! Then one day she'll die – of embroidery!

He picks up the telephone and dials.

Darling it's Sebastian Horsley again I'm afraid I am going to have to cancel my booking for lunch as the person I am meant to be meeting has rejected my offer of a grand love affair and is choosing a life of tragic domesticity with a ski instructor and a luxury fucking fondue set in Austria instead. That's right. I'm terribly sorry dear. Goodbye.

Puts phone down. Beat. Silence. He looks at her note again.

Oh Sebastian why did you have to go and send her the stupid poem? If you'd just kept it to yourself you'd be having lunch with her now and three quarters of the way to getting her into bed. I mean look at it:

He takes out the poem and reads selected lines.

'Carved her name on the wall of my cell
Ringing like a lepers bell in Hell'.
'She walked like a poem, afraid of birds and flight.' 'I am your beautiful shadow, the wound that became a scar.'
I make no wonder she's on the first flight back to Austria!
It's like I'm living in the eighteenth century.

He screws up the poem.

My trouble is I have the soul of narcissus and the spirit of Julie fucking Andrews. Every time I meet someone I even vaguely like I do the same thing: go completely OTT and drive them away. God it's exhausting, walking this fucking tightrope between vanity and insanity.

He rips up Henrietta's note.

I don't want to be a man, I want to be a mannequin!

Beat. We can hear the ticking of his clock.

There's such a loneliness in the slow movement of the hands of a clock isn't there? What now? I can't cope with situations like this where I've planned something and it doesn't happen. I have to have a very rigid structure to my life or everything implodes.

He starts to count suits

One-two-three-four-five-six-seven-eight-nine-ten-eleven-twelve-thirteen-fourteen-fifteen-sixteen-seventeen-eighteen-nineteen-twenty. Jesus Christ!

He pushes the clothes rail away violently. He looks at the gun in the picture frame on the wall.

Sometimes I really do think I should commit suicide. As Mother always said 'suicides are the aristocrats of death', a triumph of style over life. And if my life really is a work of art then it deserves a frame – if only to distinguish it from the wall. If you're an artist dying is often the best career move you can make: once you're dead you are made for life.

Beat.

Who am I kidding? I can't commit suicide, I can't commit to anything. Actually that's not strictly true.

Goes to the window. Beat.

He dives into his desk drawer and takes out a biscuit tin full of cash.

He goes out of the door and down the stairs. We hear fragments of a conversation off. He returns with the gear. He closes the shutters and starts to prepare his fix.

You know, when I was in Clouds my therapist told me I had to learn to find pleasure in little things but I can't. I'm hardwired for big things, for extremes. That was why I crucified myself, because I wanted to break the limits of my life. I wanted to escape my tainted flesh through some heroic act. But it is not possible to shed our skins. Every man is crucified upon the cross of himself.

He stops preparing his fix.

You know the ultimate irony about the crucifixion? I did the whole thing without drugs. The one time in my life when it would have been perfectly legitimate to have taken painkillers – I turned them down. I can still remember the sensations so vividly. Laying down on the cross. The nails being driven through my hands. The cross being raised. The sense of nothingness, the sensation of just being a tiny speck on the horizon, the feeling of being pinned like an insect between two eternities, between the infinity of the lake and the infinity of the sky.

He starts preparing his fix again. Rain is now belting against the window.

You see I think in the end the drug addict has a religious outlook on life. He has the faith of oblivion. It's just another way of avoiding finding the courage to just *be* isn't it – another way to shelter us from the hurricane of life. If spirituality is a form of drug pushing then maybe drugs are a form of God pushing? But in the end heroin is the only thing that really works for me, the only thing that stops me scampering round in a hamster wheel of unanswered questions. To me smack is like the missing chair leg made with such precision that it matches every splinter of the break. Don't look at me so disapprovingly. You know as well as I do that in the end virtue is something you feel you should enjoy but don't and sin is something that you're quite sure you shouldn't enjoy but do. People who say you shouldn't take drugs should try living in my head for a day. So what if Heroin kills you, life kills you. At least this way you get to live before you die.

He plunges the needle into his flesh.

Fuck! Fuck! Thank God, I'm finally home.

He breathes in the peace.

I sometimes wonder if Soho is the best place for a recovering drug addict to live, but I can't see this outfit playing so well in Hearne Hill can you? Right Sebastian, in a suit made to measure let's go in search of pleasure. What day is it?

Looks in diary.

Excellent. It's Norman Foster's Orgy night. Norman hosts those *Killing Kittens* jobs – upmarket swinging – M and S canapés – jerking in the Jacuzzi – you know the sort of thing.

He picks up the phone and dials.

Norman it's Basti are you still having a little soiree tonight?
Yes I'd love to. Absolutely. Bring a few girls! Darling I
can't even get one to turn up for lunch. OK see you around
eight.

He puts the phone down.

Last week I ended up fucking this fake aristo called
Lady Victoria. It was hilarious. She said 'I'm tired of
masturbating on marble, I want to get it on in the gutter'
so I brought her back here. Course she was in pig heaven,
she said 'darling you live on Meard Street, it means shit in
French, it's just perfect.' That's the problem for the well to
do, they have to pay to make their sex degrading whereas
for the proletariat it's rendered instantly sordid by their
natural environment. Still it's always worth seeking out the
precious grit of depravity, it stops one sliding into elegance
or worse still spirituality.

He re-opens the shutters. Light floods in.

You know when I was younger I thought the world was
against me. But now I realize the universe is neither
hostile nor friendly, it is merely indifferent. But this doesn't
worry me – quite the opposite – it makes me ecstatic! I
have reached a nirvana of negativity. I can look futility in
the face and still see promise in the stars. So I'm broke. I
shall just have to start making economies – from now on
I shall walk to The Ritz. So I live in a small brothel: I
have always held with Mr Da Vinci's conviction that small
rooms concentrate the mind. Besides I think it is wise to
live as if life is going to turn and make a fool of you at
any time don't you? And squalor is my natural setting
after all. In the long term I'm sure my name will lie still.
I won't have left a great work of art. I won't have streets,
or hospitals or charities named after me. Though I might
have a disease named after me. But it has been worth it.
To *become* a work of art has been the object of my life. And
you should never judge a work of art by its defects. Yes,
I am preposterous, vulgar, absurd and I answer no social

need whatsoever. I am a futile blast of colour in a futile colourless world. I regret everything. But so what? At least I have cause. Life is a tragedy. We get washed up on some random shore and spend our lives building shelters and waving at ships. Then the tide turns. The waves crash inwards and sweep the lost away. We are left with a desert. We end up weeping alone in an empty church. Remember me, whispers the dust. Looking back, I am glad to say that I haven't really had a life. I've just sat in a room and died. But I shall continue to lift up my face to the last rays of sunshine. I am now a reconciled Sebastian. I can allow the arrows to rest gently in my wounds.

Sebastian's shadow is now cast, crucifixion style – arms outstretched, onto the back wall.

Right, what now? Take my picture to the framers. I better sign it, then The Ivy will know which way to hang it.

He signs his sunflower painting.

That's knocked two grand off the value straight away. To think my Mother actually christened me Marcus. Marcus! Thankfully she realized she'd made a terrible mistake and had me altered by deed poll later. Sebastian is the most beautiful word in the English language. Sebastian Flyte, Sebastian Dangerfield, Sebastian Venable, the title is divine, all gleaming with vermillion. You know Mr Wilde took Sebastian as his Christian name for his alias when he went on the run to France. He also wrote 'the grave of Keats' for me: 'the youngest of the martyrs here is lain, fair as Sebastian and as early slain'. After Mother changed my name Father said 'I hope Sebastian doesn't give him any ideas.' I have to say it did rather. Now which way is the framers?

He picks up an A to Z, then tosses it down.

To hell with that, if you don't know where you are going any road will take you there.

Dons his jacket and hat.

How do I look? Jesus was wrong, It's better to go to hell well tailored than to heaven in rags. The sense of being well dressed gives me a feeling of inward tranquility which psychotherapy is powerless to bestow. I've always believed a gentleman should be impeccably dressed for the firing squad and give the order himself. Never forget style is when they are running you out of town and you make it look as though you are leading the parade.

He picks up his gear and a fresh syringe and places it in his special jacket pocket.

Just in case the orgy has any longeurs.

He picks up the Austrian's scarf.

Vienna – it means nothing to me.

He pushes it into the top pocket of his jacket as decoration.

Right I'm off into Soho – my Queendom, and this evening I'm going to fuck my brains out. Rejection always gives me an erection.

We hear a commotion outside. He looks out of the window and laughs.

Do you know there's a man in a frock with an 'End Is Nigh' sandwich board round his neck outside The Dean Street Townhouse. I know how he feels, he's probably just been given his bill. Soho's like a madhouse without walls isn't it? Men impersonating women, women impersonating men, human beings impersonating other human beings, thousands of people being lonely together. It's like a creature possessed of nothing but a stomach and a penis. But to me it's the only place that's ever felt like home.

Beat.

If you see me on old Compton Street please say hello won't you?

He exits with his painting under his arm. The Lights fade, save for a pin spot on the sunflowers, but that too eventually fades to black.

THE END.

Curtain call music: T REX 'Dandy in the Underworld'.

TIM FOUNTAIN